RECENT FORGERIES

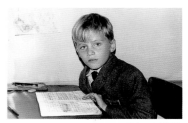

School, 1966

Viggo Mortensen: Recent Forgeries
November 21, 1998–January 9,
1999
Track 16 Gallery

Editor: Pilar Perez
Design: Ellen Wakayama and Julie
Williams
Copy Editor: Sherri Schottlaender
Photography: Bill Short

Volume VI, no. 53
ISBN 1-889195-32-4
© 1998 Smart Art Press
© 2004 Fifth Edition
Published by Smart Art Press
2525 Michigan Avenue, Bldg. C1
Santa Monica, CA 90404
(310) 264-4678 tel
(310) 264-4682 fax
www.track16.com

Distributed by RAM Publications
2525 Michigan Avenue, Bldg. A2
Santa Monica, CA 90404
(310) 453-0043 tel
(310) 264-4888 fax
e-mail: rampub@gte.net

Photomechanical by LUCAM, S.A.,
Spain

Front cover image:
Mother Memory, 1997

Back cover image:
Last Night, 1998

Printed and bound by
Jomagar, S.A., Spain

RECENT FORGERIES

※

VIGGO MORTENSEN

SMART ART PRESS

INTRODUCTION
DENNIS HOPPER

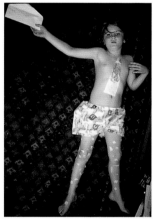

Mom's Present, 1997

We are beyond art as an object designed to amuse, bewilder, annoy. To inspire reflection is where we finally are, hopefully. Art in the twentieth century has established that it exists not to arouse admiration for only technical excellence, but to use paint and incorporate the found object and concept. Art has a vanishing point. The image from childhood takes me back. A child's head, an arm stretched over a plastic pool out into space. The shoreline may be a cloud, the vanishing point its art. It's your dilemma now. The ball is in your court. It transcends the personal artist's application and becomes yours.

Viggo Mortensen's work comes out of the right place. It comes from the subconscious. The child-creator projects the image into consciousness—you take it back into your subconscious and have your own conscious reaction. These things work for me in Viggo's art. They are immediate and unschooled. Active, free, yet weighted in tradition as new as the computer, as old as Christ. Drawings from childhood, computer experiments, canvas, cloth, photographs, rub, scratch, splash, dash. Go for it, Viggo.

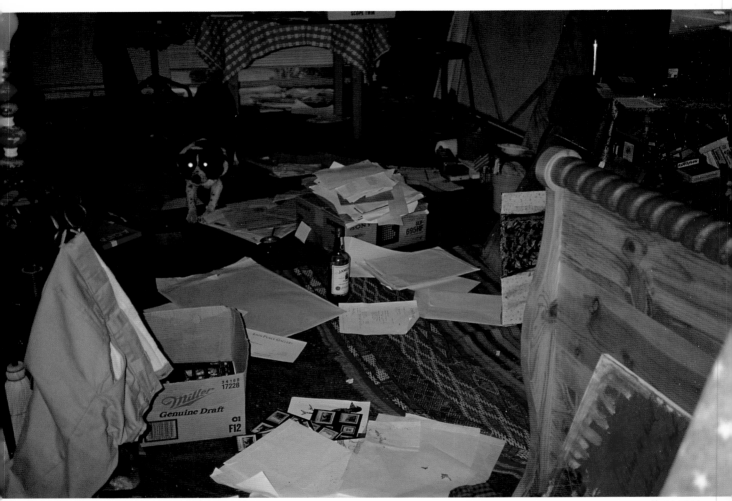

Home, 1998

Treasure Island:
A Visit with Viggo Mortensen

Kristine McKenna

Viggo Mortensen lives in a modest suburban tract house that harbors a secret —a secret that's out the minute you walk through the door: Mortensen is an artist and he is a trifle obsessed. Every inch of his house is given over to artworks, either finished or in progress. There's art in boxes, in stacks, and leaning against walls, which are hung salon-style with yet more art. The place is so layered with art that when Mortensen offers a guest a soda, he has to liberate the refrigerator from behind several large paintings in order to get to it.

Mixed in with the photographs, paintings, collages, assemblages, sculpture, and drawings are notebooks filled with poems and short stories, as well as odds and ends the artist has retrieved from the streets. Mortensen has the soul of a junkman, and the old signs, chunks of wood, and broken toys he's salvaged may or may not be incorporated into artworks, but he wants them on hand just in case. The house is like a giant compost pile that provides an inexhaustible supply of mulch, and when you see how Mortensen lives, you begin to understand how he produces so much art; it's as if he resides inside a paintbox.

"The garage is full of paintings even bigger than these," Mortensen solemnly confesses, like a child admitting to having broken a window. Despite the crowded conditions, he isn't eager to sell anything. He's attached to his stuff and doesn't want it to leave home.

In "Recent Forgeries," Mortensen shares a selection of work drawn from the vast

archive he's accumulated over the last twenty years. An accomplished poet who maintains a parallel career as an actor, Mortensen is self-taught; in this, his work has links to outsider art.

"I don't know much about twentieth-century painters," says Mortensen, who operates on instinct and intuition rather than an intellectualized approach to art-making. "Because of how I was brought up, I go along with it for awhile when somebody tells me about a rule, but eventually I always end up asking myself: Why does it have to be this way?"

Born in Manhattan in 1958, Mortensen is the oldest in a family of three boys. His mother is American, his father Danish, and the family moved frequently throughout his childhood.

"We drew a lot as children and my mother saved much of what we made. Look at this thing I recently found," he says, rummaging under some boxes and pulling

Drawing, 1966

out a surprisingly sophisticated abstraction executed in red and green. "I did this when I was seven—and look what the teacher wrote on it: 'Very Poor!' I wish I could make a painting like that now," he adds, studying the drawing intently.

Graduating from high school in Watertown, New York, in 1976, Mortensen began taking photographs while he was still in school. "I was taking lots of pictures in the late seventies and used to be really anxious about always having a camera with me—it got a little out of hand," he recalls. "It seemed that there was always something going on that I could be taking a picture of, and I suppose I eventually started feeling a little removed from life. I'm actually shooting more these days, but I'm thinking primarily about color now and assuming the framing will take care of itself since I've been doing it for so long. It's a much looser and more relaxed way of working."

The fruits of Mortensen's years of picture-taking can be seen everywhere in

his house; there are literally thousands of photographs, framed and unframed, laying around in no particular order. Looking through a randomly selected pile of images, one is struck by the lyricism that infuses Mortensen's pictures of suburban backyards, a bullfight in Spain, a bride running down the steps of a small Midwestern church as she leaves her groom at the altar, a melancholy elephant, a farm in Denmark. The images are tender and curiously chaste; there's rarely anything violent or crudely sexual in Mortensen's photographs.

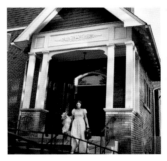

His paintings have a bit more edge, revolving as they do around the layering of disparate elements; text, for instance, will be faintly scribbled over an image painted onto a scrap of patterned wallpaper that's been glued to an old door. The aggression of this unholy mix of materials is intensified by the large scale that Mortensen often favors.

"I'm not arrogant enough to say I haven't been influenced by anyone, but the way I work has mostly been shaped just by being in the world and looking," he says. "I saw some shows in New York last fall, including the Rauschenberg retrospective at the Guggenheim, and there were things that made me think, oh no, some of my stuff really looks like this—people might think I am stealing."

"So much has already been done and there's not much that's new," he concludes. "You can't let that stop you though, because the actual exercise of just poking around in the debris is worthwhile. Even if you produce stuff that's interesting to nobody but yourself, the activity justifies itself. Making things is a way of finding out."

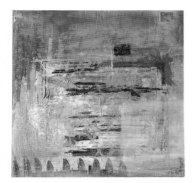

Sun's Losing Its Yellow, 1998

Called Off, 1985

9

Thank you: Track 16.Tom Patchett.Pilar Perez.Dennis Hopper.Victoria Duffy.
Ellen Wakayama.Julie Williams.Susan Martin.Bill Short.Chris Doyle.Lindsey
Bryce.Lisa Darling.Paula Symonds.Hugh Milstein.Mike McGann.Michel Karman
Photo Impact.A&I.Jolie Marguiles.Steve Moulton.Don Weinstein.Black.White.
Red.Blue.Yellow.Andrew Davis.Peter M. Scott.Kopelsons.Men.Girls.Boys.Horus.
Dogs.Pigs.Elephants.Roosters.Cats.Cats.Cats.Calves.Harriet Zucker.Horses.
Family Here.Family There.Deer.Geese.Grouse.Fish.Ducks.Cows.Mermaids.Lynn
Rawlins.Italia.Diane Lane.Ray Loriga.Christina Rosenvinge.Mickey Rourke.
Beyond Baroque.Johnny Hartman.Bob Flanagan.Jeff Wright.Wrights.Jim Krusoe.
Shakespeare.FrancEye.Greenpoint.Venice.Indiana.Halina Bober.Jose Luis Acosta.
Polska.Meryl Streep.Nelly.Exene Cervenka.Henry Mortensen.Hank Mortensen.
Christine Lee C. Brigit.Pacific Ocean.John Duchac.Atlantic Ocean.X.John Doe.
Nommensens.Blakes.Maria Falconetti.Karl Nilsson.Carl Theodor Dreyer.Vidiots.
Jessica Lange.Dawn.Sunrise.Morning.Noon.Afternoon.Sundown.Twilight.Dusk.
Night.Midnight.Witching Hour.Wolf Hour.Farmors Flaeskesteg.Farfars Cigar.
Dulce de Leche.Mate.Grøn Tuborg.Jamesons.Rød Aalborg.Snow.Rain.Fog.Wind.
Hail.Sleet.Mud.Clouds.Lightning.Thunder.Rainbow.Northern Lights.Shameless.
Mike Welch.Zak Marmalefsky.Jackson Seidenberg.Julian Scalia.David Warshofsky.
Andrew Wilkes.John Lofasso.Brandts.Chris Bishop.Ahmed Abdullah.Walter
Donohue.Pedro Almodóvar.North Sea.English Channel.Baltic Sea.Samsø.Sjælland.
Jylland.Føroyar.Rio de la Plata.Manhattan.Manhattan.Manhattan.Chaco.Cordoba.
Björn Borg.Lena Stavenhagen.St Lawrence River.Lake Ontario.Black River.Hanna
Brogren.Beaver Meadow.Crystal Restaurant.Andy Joynt.Tom George.Bill Blance.
Garritys.Work.Patience.Humiliation.Allan Simonsen.Jack Kerouac.Jeanne
McCarthy.Bill Treusch.Tobie Haggerty.Luke Reilly.Sandy Dennis.Sandy Dennis.
Sandy Dennis.Eric Roberts.Sean Penn.Bonnie Timmerman.San Lorenzo de Almagro.
Warren Robertson.Tony Richmond.Don Phillips.Rio Bermejo.Ric Tigre.Mario
Kempes.Viggo Stuckenberg.Rio Paraná.Kattegat.Norge.Sverige.Suomi.Knut Hamsun.
Karen Blixen.Mario Benedetti.Dirk Bogarde.Kim Stanley.Venus.Diana.Thalia.
Jack Kehoe.Scott Wilson.Nancy Johnson.Jesus Christ.Lynn Rawlins.Andrew
Gabin.Jane Berliner.The Carpenters.Lars von Trier.Lightning Creek.Henning
Bendtsen.Sven Nykvist.Storaro.Clark Fork River.Elisabeth Trisenaar.Mike
Mitchell.Grips.Electric.Art Department.Props.Camera.Animals.Casting.Hair.
Make-Up.Craft Service.Sound.Director.Editing.First Aid.Extras.Locations.
Producer.Publicity.Script.Script.Script.Set Dressing.Special FX.Lapland.
H.C.Andersen.Jacob Riis.Rolling.Action.Cut.Go Again.One More.Last One.Just
One More.Martini.Stand-Ins.Stunts.Technical Advisor.Rilke.Transportation.
Sandpoint.Lake Pend Oreille.Spokane.Clark Fork.Bonners Ferry.Ontario.Air.
British Columbia.Alberta.Idaho.Visual FX.Wardrobe.Pack River.Quebec.L7.
John Roecker.Willy Mrasek.Judy Garland.Stone Fox.Tammy Wynette.George Jones.
Old 97s.Matt Freeman.Rancid.West Fort.Fred Dewey.Tosh Berman.Lola Schnabel.
Julian Schnabel.Ada Falcon.Carlos Gardel.Attilio Belfiore.Marvel.D.C.Mattel.
Kenner.Hasbro.The Replacements.Dwight Yoakam.Marcelo Pineyro.Buckowens.
Vince Vaughn.Trolls.Matthew Vought.Olga.Liliana.Marta.Fru Andersen.Del
Aften.Eduardo Falu.Ashley Judd.Philip Ridley.Lindsay Duncan.Pablo
Despeyroux.Gwyneth Paltrow.Michael Douglas.Trolls.Trolls.Greta Garbo.Ruth
Lauridsen.Morten Lauridsen.Roland Kirk.Pat Healy.Poetry.Buckethead.Duke
McVinnie.Tom Janniello.Tracy Thielen.Liza Richardson.Andy Armer.James Cruce.
Travis Dickerson.Snekkerup.Outrup Varde.Esbjerg.Nibjerg.Ruth Lauridsen.
Jeremy Cooper.Björk.Nørrebro.Tex Avery.Chris Walken.Rimbaud.Neruda.Lorca.
Minerva Chapman.Kornelia Ender.John de Boorman.Underdog.Robbie Jacks.Sleep.
Japan.España.Uruguay.Tony Gilkyson.Margaret Comer.36th St./9th Ave. Tony
Scott.Ridley Scott.Vickie Thomas.Joan Darling.Stephen Huvane.Polly Lazarus
Ringsted.Roskilde.Smell.Sight.Sight.Sight.Hearing.Touch.Taste.Buenos Aires.
Resistencia.Berlin.Africa.The Shandon Star.Nickodell's.Ship's.The Playboy.
Munich.Santiago.Barcelona.Crying.København.Madrid.Cairo.Stockholm.Oslo.
Trondheim.Ice.Helsinki.Punta del Este.Singing.Laughing.Laughter.Eskebjerg
Lyng.Kalundborg.Pyromanens Hus.Bjergsted.Beech.Birch.Oak.Pine.Tyderup.
Ugerløse.Skovlunde.Bromarf.Pilar.Halsskov.Cruz Chica.Cruz Grande.Memory.
Memory.Memory.Prayer.Tasunke Witko.Wakan Tanka.Thor.Odin.Freja.Broken Bones.
Cuts.Burns.Scrapes.Birds.Sprains.Tears.Tears.Infection.Inflamation.Bruises.
Maple.Cottonwood.Jeppe Mortensen.Sun.Moon.Sweat.Work.Work.Work.Strangers.
Strangers.Strangers.Watertown.Burrville.Clayton.Cape Vincent.Dirt.Water.
Oils.Smoke.Danny Stewart.Malcolm.Anne.Sjørn.1966.1998.Peter Schneidre.Peter
Owen.Hillary Fox.Ringsted Dampmølle.B&W.KFK.More Work.Pain.Losing.Books.
Movies.Singing.Songs.Dancing.Walking.Running.Drinking.Eating.Sex.Love.Time.
Sailing.Swimming.Climbing.Good Advice.Signs.Warnings.Friends.
Enemies.Lovers.Mother.Father.Brothers.Son.Women.Women.Women.Sleep, and all
MY ENEMIES ARE HEREBY SALUTED

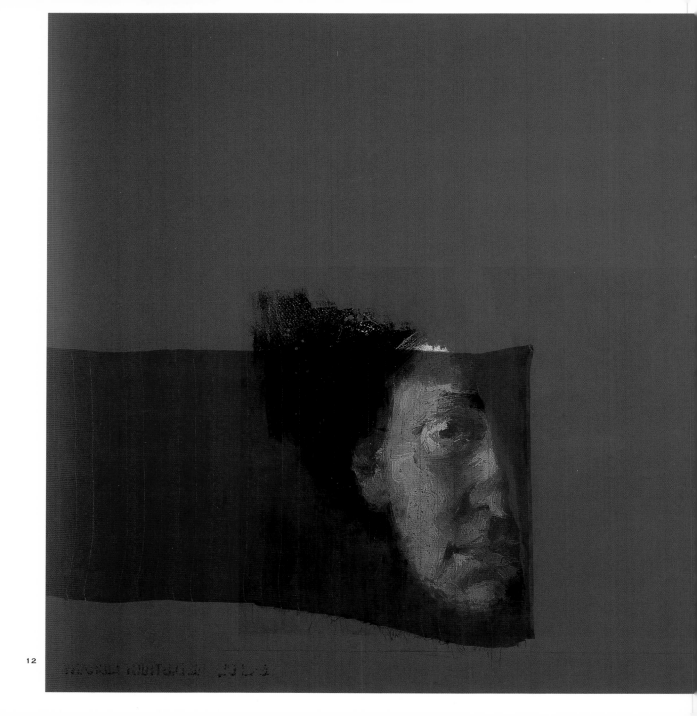

Red Minerva, 1997

13

You are sweating in your sleep
on our rented bed
like a lost summer cloud
pierced by a jet heard
only when it's gone.

The birds above the waterfall
drink mist from giant leaves
then fly over the edge.

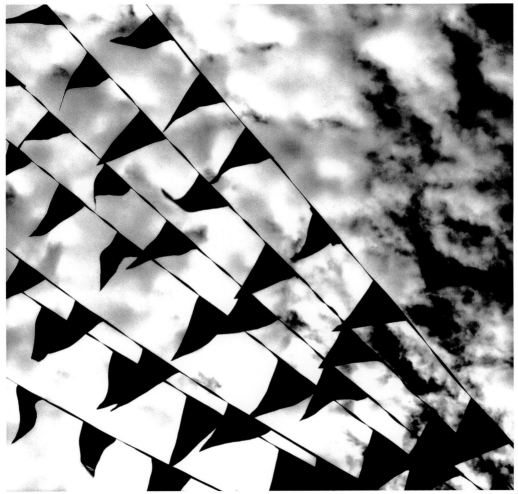

Manhattan, 1985

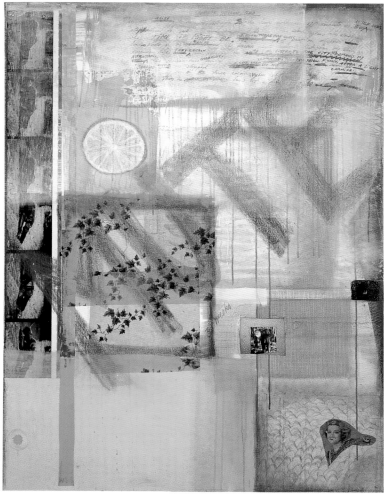

Mute, 1998

WADING

PIECES OF YOU DRIFT BY
IN THE DEAD OF THE AFTERNOON
ON THE YELLOW TIP OF A WAVE.

THE SHARK THAT CAME TO SHORE
AT THE END OF YESTERDAY
ROLLS SICKLY, BUMPING CORAL
LIKE A TIRED DRUNK
TO AVOID BEING EATEN
AT LOW TIDE.
HE'S NOT AFRAID OF ME;
I'M THINKING OF YOU.
SO MUCH GONE FROM MEMORY
THAT I'M LEFT WITH
JUST YOUR TEETH.

Wall, 1997

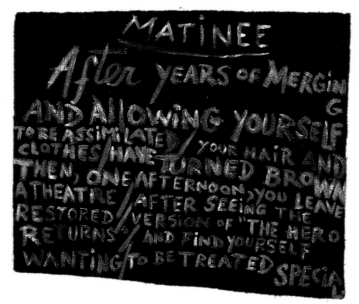

Matinee, 1997

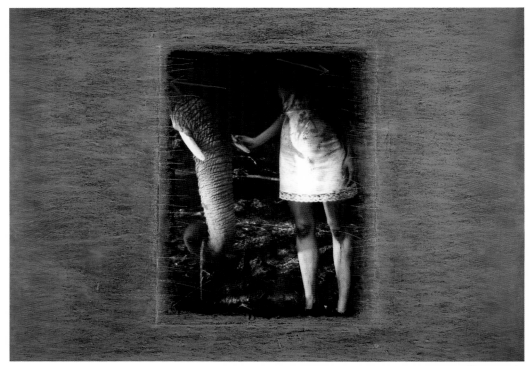

Blue #1, 1997

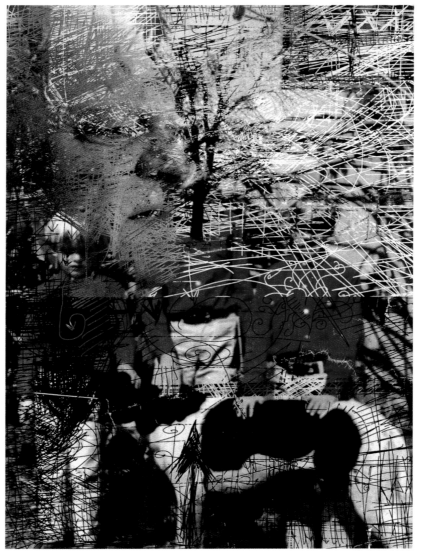

Red #3, 1997

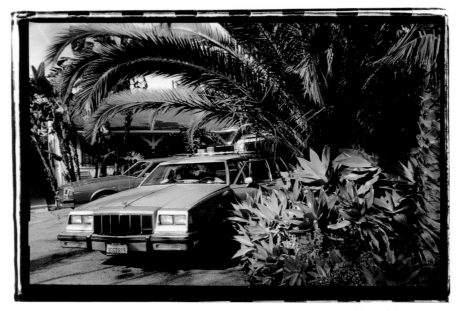

Venice Driveway, 1997

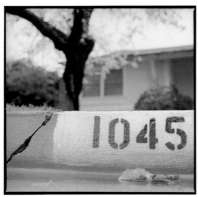

1045, 1998

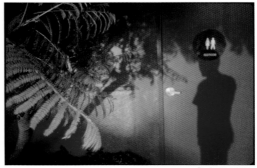

Red #6, 1998

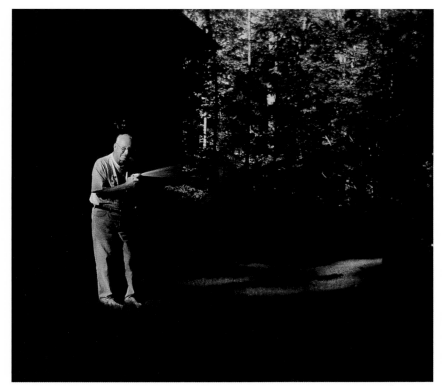

Gray, 1997

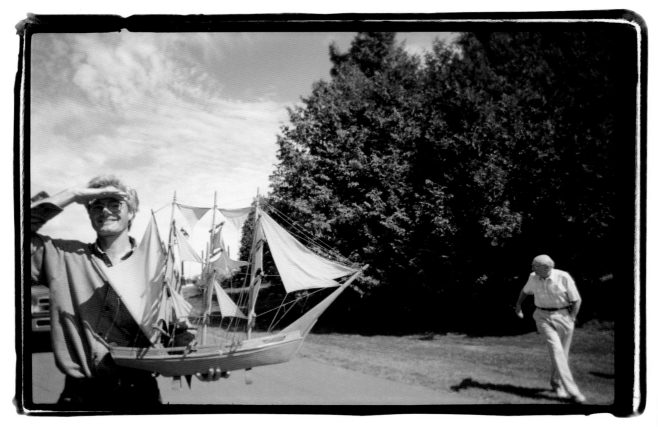

Departure, 1997

CLEAR

I FIRST HEARD YOUR VOICE FROM AN AIRPLANE. YOU TOLD ME YOU HAD CRYSTAL KNEES AND COULDN'T STOP THINKING ABOUT JEAN SEBERG'S FOETUS BABY IN ITS GLASS COFFIN TO PROVE IT WASN'T BLACK AT ALL. I WANTED TO HANG UP, OR POLITELY SAY GOODBYE AND THEN CHANGE MY NUMBER AND NEVER ANSWER THE PHONE AGAIN UNTIL I KNEW YOU WERE DEAD. BUT YOU KEPT SAYING THINGS I WANTED TO HEAR, LIKE THAT A WINDOW MIGHT AS WELL BE A WALL BUT THANK GOD FOR FISH TANKS AND BOTTLES.

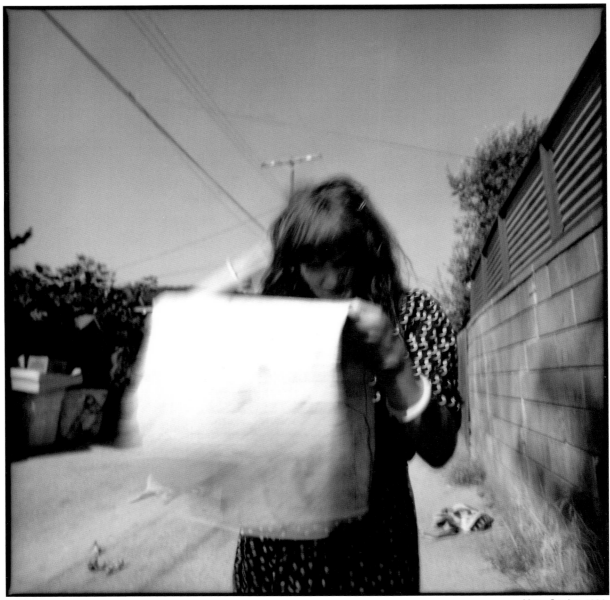

Metro Section, 1996

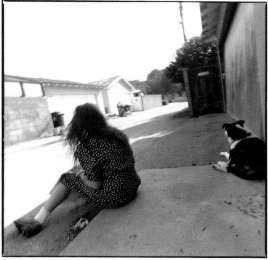

Exene's World, 1996

Cuttings

The afterthought of chimes
filters in from next-door.
I am under the echo, not
listening so much as noticing
it from time to time as
I look over the results
of my landscaping and
weeding from a white
wicker chair.

An errant vine has sprouted
two blue flowers
where it reaches
roots of the lemon tree.
They are beautiful;
I am suspicious.
Are they a diversion,
an entreaty to keep me
from cutting back the vine?
I'll keep the flowers,
put them in a saucer
by your bed.

Offerings, 1996

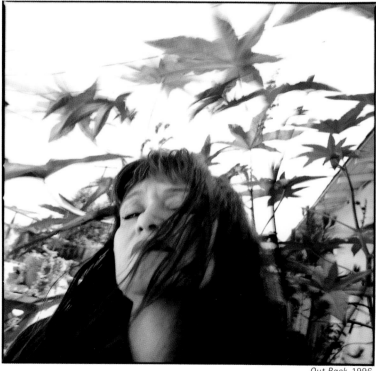

Out Back, 1996

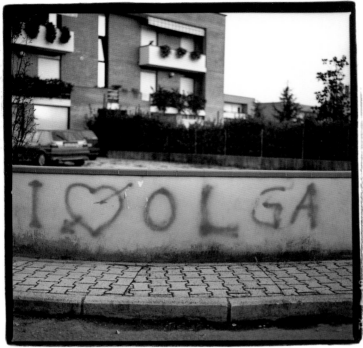

I Love Olga, 1995

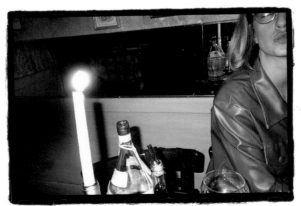

Nancy, 1996

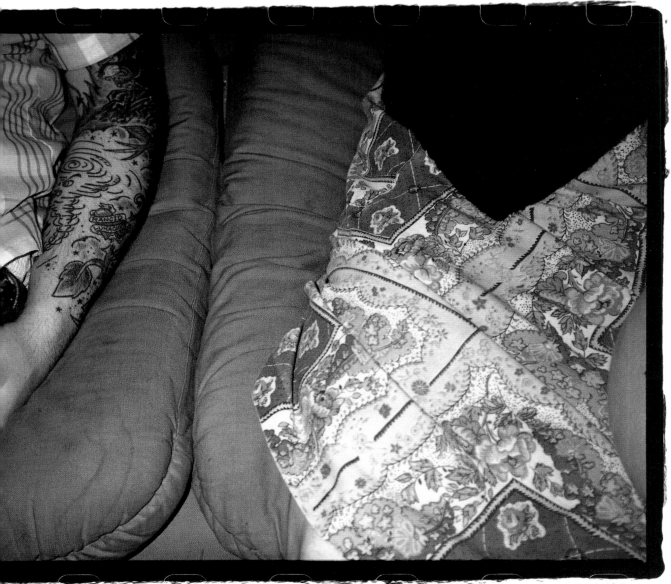

Matched Pair, 1996

Second Opinion

The glow inside another red-crossed pelvis
will drain when they crush that little bulb.
Menstrual minstrels drift in
from the weedless garden.
The immaculate blue flame
from the fake fireplace
burns the corner of my eye.
Can't stop staring at nothing.
A gloved hand opens the door,
and the man enters soothingly,
with an air of respect for the dead.
Encourages us to look on the bright side.
Black pants hide your pain afterwards,
and there's a cookie on a napkin
and a paper cup of red juice
to replace your strength.
We drive home without blinking
because the sun isn't real.

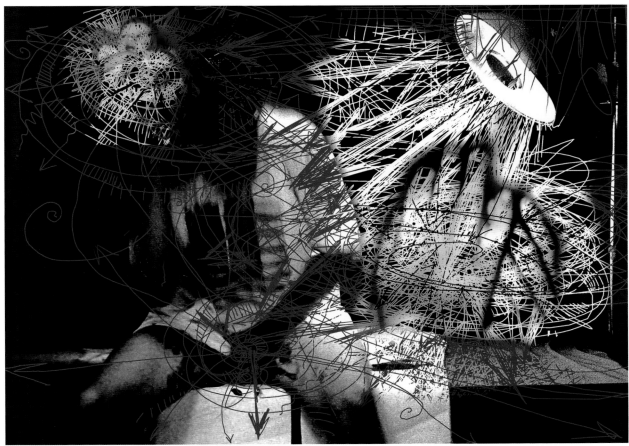

Clinic, 1997
(With an image by Paula Symonds)

CURSIVE

OUTSIDE, FOREPLAY OF RAIN CLOUDS.
INSIDE, YOU WRITE IN YOUR DIARY—
PROBABLY ABOUT THE ARGUMENT WE'VE
BEEN HAVING ON AND OFF ALL MORNING.
LITTLE PEN, NEVER STOPS. NOTHING
OMITTED, EVERYTHING REWRITTEN. SHARED
PAST BECOMES ROPE, STRETCHES NECKS.
WE DON'T FIGHT; WE DON'T LOSE.
SHORTHANDS PRESENT YOU. I AM EXPOSED.
IT'S NOT PERSONAL, YOU SAY, IT'S ART. IT'S
DEFENCE, I SAY. I'LL PUT ON MY CLOTHES.

TRAGUÉ EL BAGRE
Y EL ANZUELO
Y LA FE QUE
TAN DULCE TENÍA
LA TARDE DEL DIA
QUE TE CONOCÍ.

ME VI EN TUS OJOS
Y EN TUS BRAZOS;
UNA VIDA ENTERA
EN TU BOCA VIVÍ
LA TARDE DEL DIA
QUE TE CONOCÍ.

Otoño Catalán

Tarde nublada, brisa
cálida.
Granitos de olvido
en tus pestañas.
Te veo, te llamo.
Pienso que hablo
en voz alta.
Me traga el trafico;
me alegro. Voy medio
mojado, casi limpio.
No pido ni tengo
que dar el perdon.

Ten Last Night

I pass a pile of broken chairs
on our street corner
and feel you
drying on me.
I taste the blood
that shimmered
on your lips.
Lingering, like guilt does.

Just Coffee

He wanted bigger love,
had to have it like he
had to dream himself
to sleep. Recrossed
his legs and waited
for her tears. When
they came, he held
her hand, pretended
to be interested in
someone walking by
their table.

LUNCH

She told me she was in love, and that she just wanted to enjoy it for as long as it lasted. That she didn't want to judge the feeling, compare it to other times with other partners. There was nothing gained from analysing, she said—all it did was rob you of time better spent in those new arms. There wasn't anything for me to say. I listened, and imagined the memorable summer she was having. Sitting across from her, I could feel how easily her breathing came. She seemed stronger than I remembered. It was pleasant to be with her. I forgot about my work, my family, the weather— everything. I almost forgot to pay the check. Suddenly, she was kissing me on the cheek and hurrying home to him, leaving me staring out the plate glass at the lushness of a willow. After finishing my coffee, I walked slowly across the park, in no hurry to get back to the office.

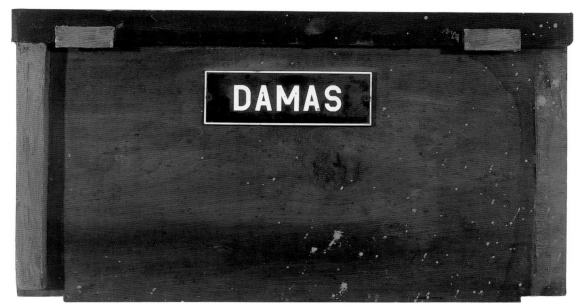

Damas, 1997

Cul, 1998

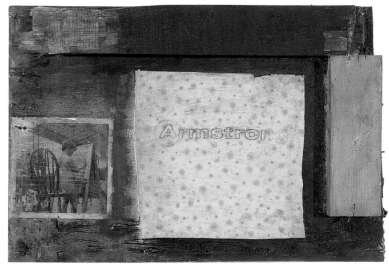

Armstrong, 1998

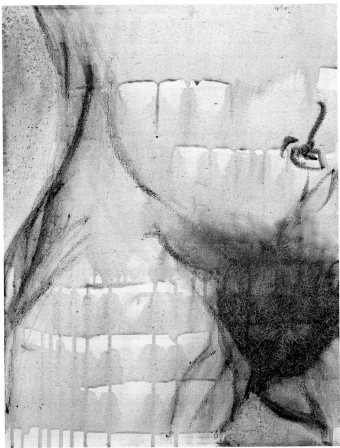

Loves of a Blonde, 1998

Pope's Apology, 1998

Work 1951, 1997

MEET

THERE ARE PLACES BEHIND CATHEDRALS WHERE PEOPLE COME TOGETHER AFTER MASS AS OPENLY AS THEY DARE IN THE LIGHT OF DAY. THEY ALSO MEET IN WEED GARDENS, IN FALLOW FIELDS, IN STAGNANT WATER, MANY OF THEM ON THEIR HANDS AND KNEES. IN CITIES, THESE SECRET UNIONS TAKE COVER IN THE SHADOW OF STIFLING MUSEUMS OF ART AND TECHNOLOGY, ON FIRE ESCAPES, AND IN COLD BASEMENTS FILLED WITH FORGOTTEN JUNK. THEY ARRIVE IN ONES AND TWOS, WITH WANTING EYES IN THE BACK OF THEIR HEADS, RIDING THE DECAYED MEANS OF TRANSPORTATION BEGRUDGED TO THE NAMELESS. THEY WAIT SILENTLY UNDER BANKS AND RESTAURANTS FOR LATE TRAINS, WATCHING OILY BROWN ROPES SPIN OUT AND STRETCH FOR NAVIGATING BLIND, CRIPPLED NARROWS BETWEEN BLACKENED COLUMNS OF CRUMBLING MARBLE. CHILDREN PLAY THERE AFTER DARK, ON THE RAZOR RAILS WHERE RUSTY WHEELS ONLY STOP SHRIEKING FOR THREE HOURS EVERY NIGHT.

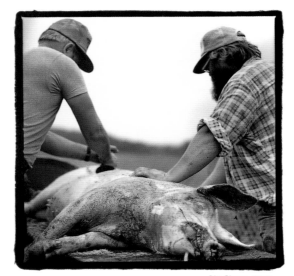

Pig Shave, 1985

LETTER FROM NEBRASKA

THERE HASN'T BEEN A SUMMER LIKE THIS SINCE BEFORE THE WAR, SO I'M TOLD. FLASH LIGHTNING FROM A CLEAR SKY WHEN EVERYONE IS OUTSIDE. THE ANIMALS HAVE BEEN MULTIPLYING AT NIGHT. THERE IS NEVER ENOUGH TO EAT. FORTY OR FIFTY MURDERS EVERY DAY, AND GOD KNOWS HOW MUCH VIOLENCE PASSES FOR DISCIPLINE BEHIND TORTURED WALLS. CHILDREN GO AROUND CLENCHING THEIR FISTS AND STARING DOWN AT THEIR SHOES BEFORE THEY KNOW HOW TO READ. THERE HAVE BEEN DROWNINGS. SOMEHOW WE HAVE FORGOTTEN HOW TO SWIM. IT CAN NO LONGER BE TAUGHT. THE WATER IS DANGEROUS. PEOPLE ARE AFRAID TO WATER THEIR LAWNS, THE BRIDGES ARE UNUSED. IT NEVER RAINS. THE SUN IS LOSING ITS YELLOW AND THE CLOUDS ARE CURLING UP AT THE EDGES. THE RADIO PLAYS TWENTY-YEAR-OLD SONGS TWENTY-FOUR HOURS A DAY. I HAVEN'T SAID A WORD SINCE APRIL.

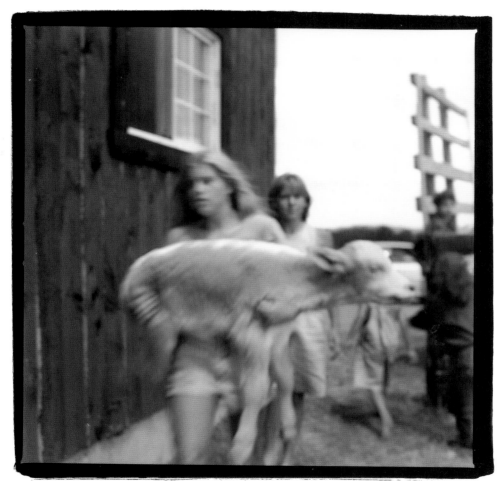

Calf Save, 1997

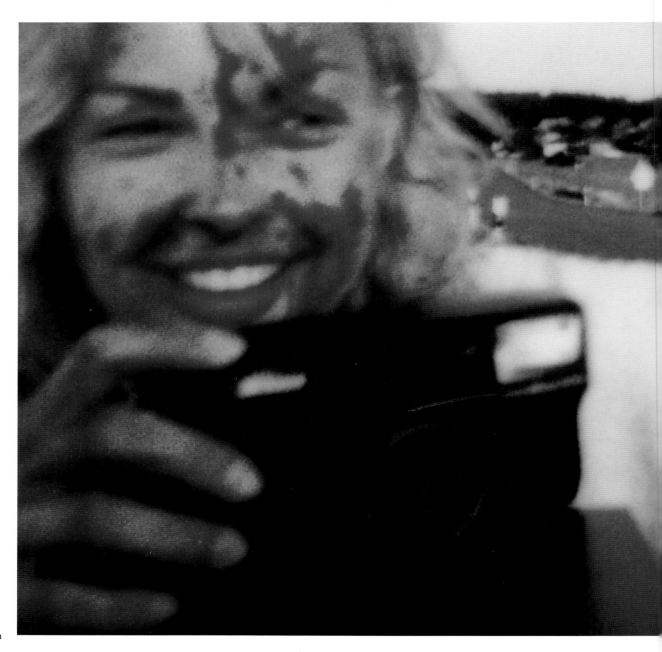

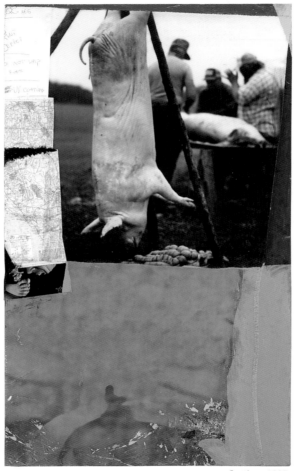

Sections, 1997

Saxon Morning, 1994

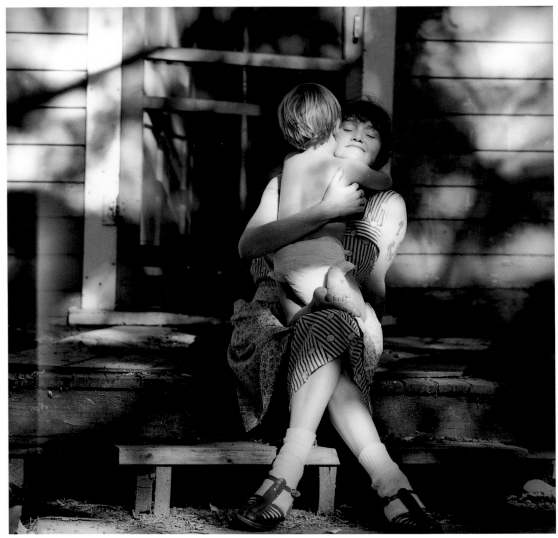

Home, 1990

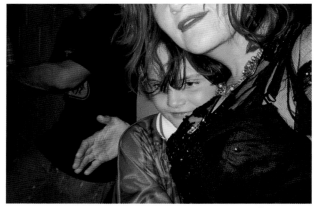

At the Forum, 1998

STONES

MET BY A LAKE NEAR THE SUN.
YOUR MOUTH AND EYES, ARMS
AND LEGS, MELTED AS THOUGH
WE'D KNOWN EACH OTHER WELL
AND NEEDED ONLY REKINDLE
WARMTH OF THE FAMILIAR.
AS IF PATIENCE WERE REWARDED
AND NOW WE'D SHARE EVERYTHING.

Green #3, 1998

Red #2, 1996

WET DOG

CRINGES, HIDES AS WE DO FROM AFFECTION.
HEAD PULLED AWAY, LOOKING OUT SIDEWAYS
FROM BEHIND RAISED SHOULDER BLADES,
SQUEEZING ITSELF INTO THE MILDEWED BACK
CORNER OF THE HALF-TILED, HALF-ROTTEN
CEMENT SHOWER STALL WITH QUAKING WET
LEGS. PEEING ON THE PLASTIC CURTAIN,
AFRAID OF THE BEATING IT LIVES TO WAIT
FOR.

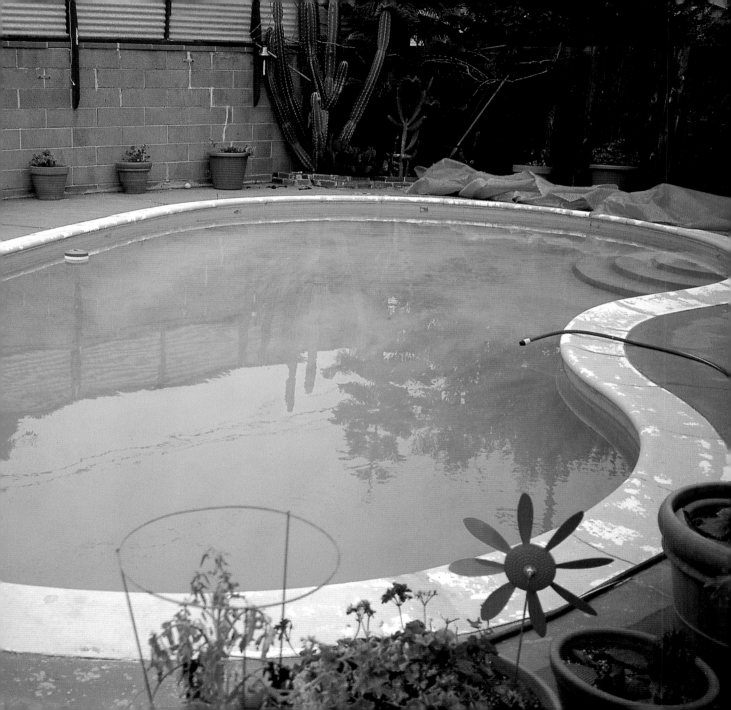

Mermaids #4, 1998

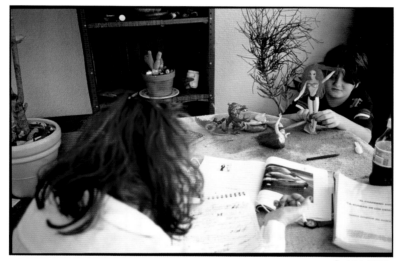

Red #4, 1998

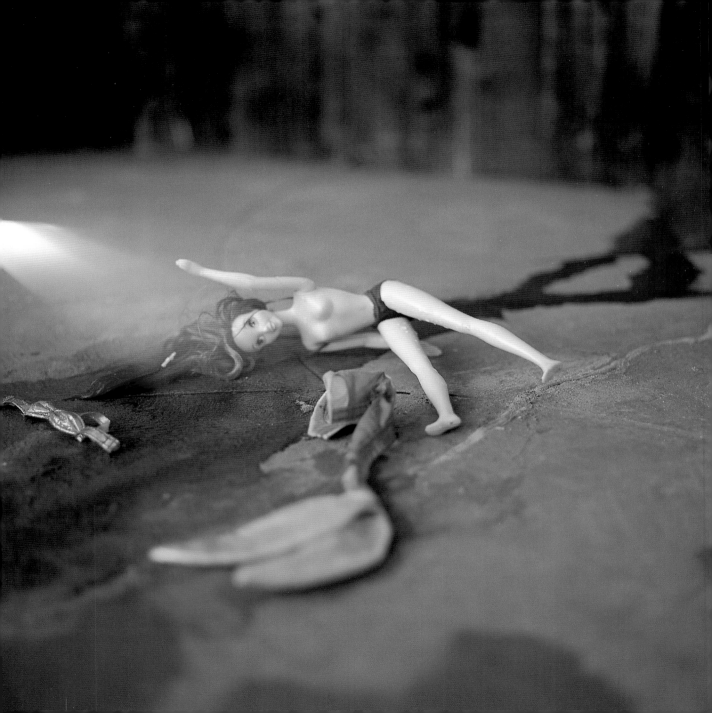

After the flower bath
petals caught in hair
on the drain cover.
He misses her,
corsage saver
keeper
of children's artwork,
whose blue-holed flesh
is used to parting
with sacrifices
to boys' trials
and men's desires,
and wonders now
what there was
to be afraid of.

Dunk, 1996

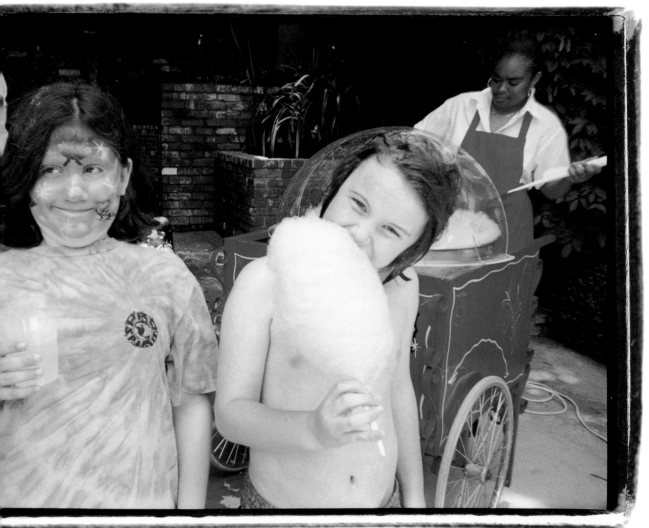

Birthday Party, 1996

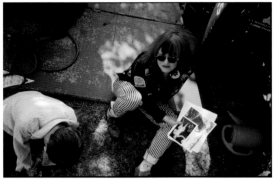

Out Front, 1998

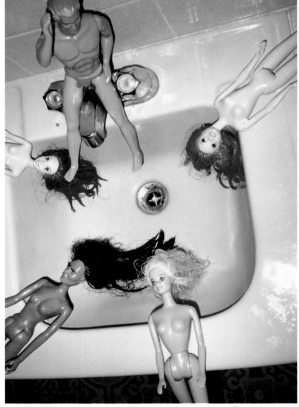

Cheating, 1998

Resting, 1998

SPRING FAIR

FOUR MERMAIDS ENTERED THE TENT
MUCH TO THE DELIGHT OF FATHERS
BOYS AND GIRLS,
MUCH TO THE DISMAY OF
MANY MOTHERS THERE.

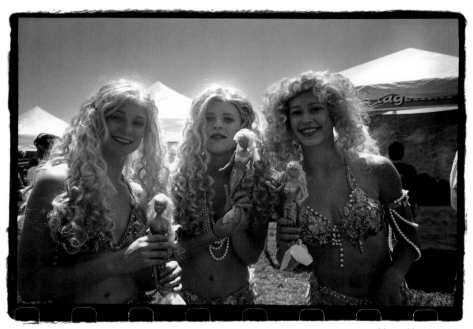

Mermaids #3, 1997

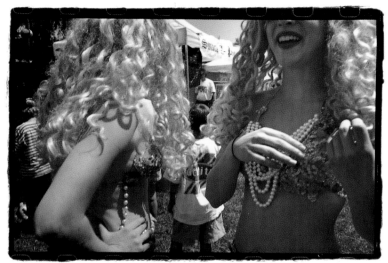

Mermaids #2, 1997

THEY ROLL OVER ON THE SWELLS
AND FORGET THEMSELVES,
FLOATING ON A SEA LITTERED
WITH BROKEN OARS AND SCRAPS
OF SAILS. THEY'LL HANG ON CHAINS
AROUND TEENAGE NECKS, LONG AFTER
SINKING, PIECE BY PIECE, AWAY FROM
THE MOON.

SHOW

THE NIGHT WAS OF TWIRLING INCONSEQUENCE TO THEM. A WASTE OF TIME. NO AMOUNT OF DRINKING OR SMALL TALK COULD ALLEVIATE THE OVERWHELMING BOREDOM INDUCED BY A SEEMINGLY ENDLESS PARADE OF AMATEUR ACROBATIC DISPLAYS. SENSING THIS, THE PERFORMERS TOOK MORE RISKS, ATTEMPTING STUNTS THAT HAD NOT BEEN PERFECTED. THIS ONLY SERVED TO IRRITATE THE AUDIENCE, AS IT FURTHER PROLONGED THE EVENING WITH INSUFFERABLE DRUM-ROLLS AND FALSE STARTS.

WHEN A BOY FELL OFF THE HIGH-WIRE MOTORCYCLE INTO THE SHARK POND AND WAS INSTANTLY TORN APART, IT ELICITED NO MORE THAN A MURMUR OF DISTRACTED INTEREST. ONCE THE LAST PIECE OF HIM HAD DISAPPEARED UNDER THE BLOODIED LILY PADS, THEY WERE BACK TO NURSING THEIR ICED THERMOSES, QUIBBLING BITTERLY AS THEY CHECKED THEIR WATCHES AND CALLED THEIR PHONE MACHINES.

THE BOY WHO CRIED WOLF IS
THE MAN WHO CAN'T DECIDE.
CAN'T LIE; NEVER GETS AWAY
WITH IT. SAVES FEATHERS
HE FINDS, BELIEVING
THEY COME FROM
DREAMERS' WINGS.

WISHING SO HARD, HE
STARTS LOOKING LIKE
OTHERS, ABSORBS THEM.
WISHING LIKE THAT
WEARS HIM OUT
AFTER A WHILE
AND THEN HE FEELS
SORRY FOR HIMSELF
AND TAKES IT OUT
ON ANYONE THAT SEEMS
WEAK.

Edit

No ringside seats compensate,
nothing new to be said
about a job completed
for you by others
in windowless rooms.

A half-soul in transit,
the man you were
for one short season
has been pruned,
removed
to a well-groomed graveyard
that smells like popcorn.

RELAY

HE CROUCHES IN THE LEE OF A PLEXIGLAS BUS SHELTER TO LIGHT HIS FIRST CIGARETTE OF THE DAY. THIS ACCOMPLISHED, HE STRAIGHTENS AND STRIDES AWAY, QUICKLY ACCELERATING INTO HIS USUAL HIGH-SPEED LOPE. MOTION IS SANCTUARY. HE IS ACCUSTOMED TO KEEPING THIS RACE-WALK PACE FOR HOURS AT A TIME, BACK AND FORTH ON THE SAME STRETCH OF SUNSET BOULEVARD BETWEEN WESTERN AND VINE. "DON'T WALK" SIGNALS ANNOY HIM, AND HE INVARIABLY DISREGARDS THEM, FINDING RECKLESS GAPS IN THE HONKING, GRINDING TRAFFIC. NO INTERSECTION IS FORBIDDEN TO HIM. INCREDIBLY, HE'S ONLY BEEN TICKETED AND FINED ONCE IN NINE YEARS, AND HAS NEVER SUFFERED MORE THAN A BRUSH FROM A PASSING BUMPER. HE OFTEN RUNS OVER CAR HOODS WITHOUT BREAKING STRIDE, AND USES BUSES NUDGING THEIR WAY BACK INTO THE NOON STREAM AS SHIELDS. HE IS THINKING OF BUYING HIMSELF ONE OF THOSE LONG, FLAT BLACK WALLETS WITH A CHAIN ON IT WHEN A BRAND-NEW HARLEY OWNER ON HER WAY TO THE HEALTH CLUB RUNS THE LIGHT ON GOWER AND PITCHES HIM THROUGH THE GLASS AT DENNY'S. IN LESS TIME THAN IS TAKES THE POLICE TO ARRIVE, HE BLEEDS TO DEATH ON THE SALAD BAR. THE ONE WOMAN IN THE LADIES' ROOM AT THE TIME, AN UNEMPLOYED ACTRESS FROM MISSOURI, COMES OUT TO SEE WHAT ALL THE NOISE IS ABOUT. SHE REALISES THAT, IN ALL THE COMMOTION, SHE CAN EASILY WALK OUT ON HER CHECK. THIS IS NOT UNUSUAL FOR HER; TRAGEDY HAS OFTEN BEEN HER ALLY.

INDEPENDENCE

THEY WOUND UP INTO THE HILLS, KNOWING ONLY THAT THEY WERE CLIMBING AWAY FROM THE CITY'S MAIN DRAGS. PAST THE STACKS OF WELL-TENDED AND UNATTENDED RESIDENCES; INVESTMENTS FOR SOME AND JUST HOMES FOR OTHERS. IRRIGATED, ORDERLY, PROTECTED. STEEP DRIVEWAYS TWISTING BACK DARKLY FROM JUNGLED GATEWAYS, FORBIDDING ENTRANCES HINTING AT MYSTERIOUS FRUITS OF MYSTERIOUS LABOURS. NOT A DOG OR PEDESTRIAN TO BE SEEN, ONLY CONFIDENT HEADLIGHTS WHIPPING INTO VIEW OUT OF THE TROPICAL NIGHT. WITH EACH STARTLING TURN OF THE PINCHED ROAD THEY'D SMELL A DIFFERENT KIND OF FLOWER. THEY COULDN'T STOP GRINNING AT THEIR GREAT FORTUNE: THESE WERE THE HOMES OF MOVIE STARS, OF ILLICIT MEETINGS, INTOXICATED PALM GARDENS, UNKNOWN PHONE NUMBERS—THE BREEDING GROUNDS OF FAME! SUDDENLY, THEY WERE OUT IN THE OPEN AGAIN, ON A DESERTED BEND OF MULHOLLAND WHERE THEY HUNG HIGH ABOVE THE FIREWORKED VALLEY. THIS WAS BETTER THAN THE VIEW YESTERDAY FROM THE GRIFFITH OBSERVATORY—OR MAYBE JUST AS GOOD, ONLY DIFFERENT. THEY HAD DRIVEN UP AND DOWN THE PHONE-POLE FILTHINESS OF SANTA MONICA BOULEVARD AND FOUND IT UPLIFTING. THEY HAD SWUM IN THE PACIFIC OCEAN. THEY HAD WALKED HOLLYWOOD BOULEVARD, IN AND OUT OF MOVIE THEATRES JUST TO LOOK AT THE POSTERS. REVERENT AS THEY EXAMINED THE JAMES DEAN STORES. WILDLY EXUBERANT THROUGH HUMPED-UP SATURDAY-NIGHT TRAFFIC. IT WAS ALL PART OF A WONDERFUL SECRET, AN INFINITE NUMBER OF WELCOMING GIFTS THAT HAD LAIN WAITING IN THE SUN.

North Sylvan Road

After the service, your family took everything from your house that your friends could not give away or hide, and pretended not to notice all the orphans you'd taken in over the years as they rushed from spotless room to spotless room sidestepping bedpans and waist-high piles of bandages, arms loaded with indiscriminately plundered moments you'd wrapped in Irish handkerchiefs and hidden behind the toilet bowl or in the embroidery of your special pillowcase.

Red #1, 1995

Red #5, 1998

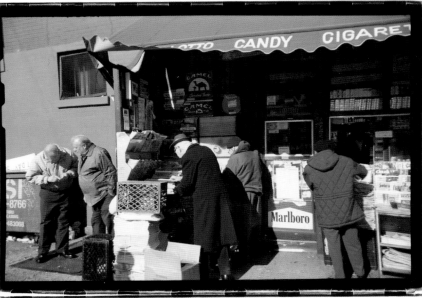

Greenpoint News, 1997

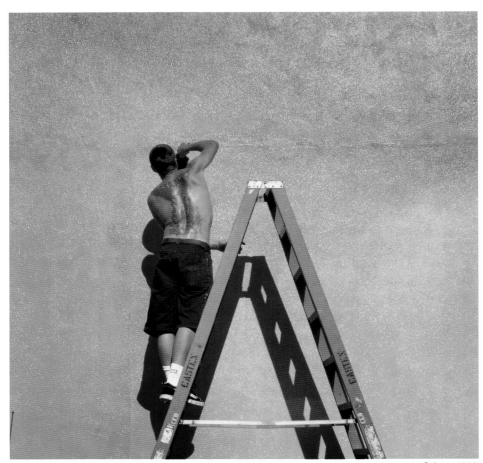

Painter, 1998

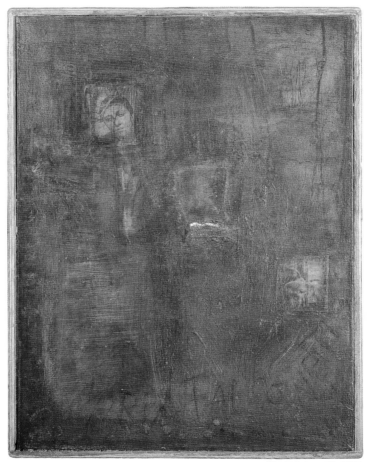

Maria Falconetti, 1998

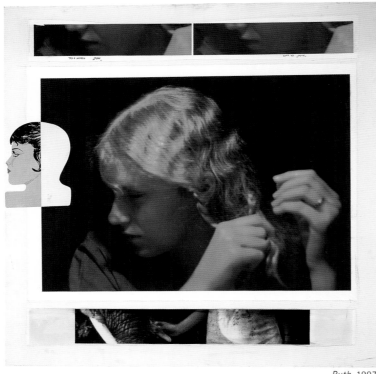

Ruth, 1997

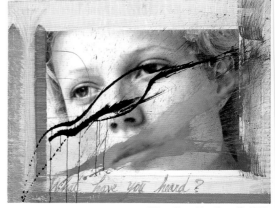

What Have You Heard?, 1997

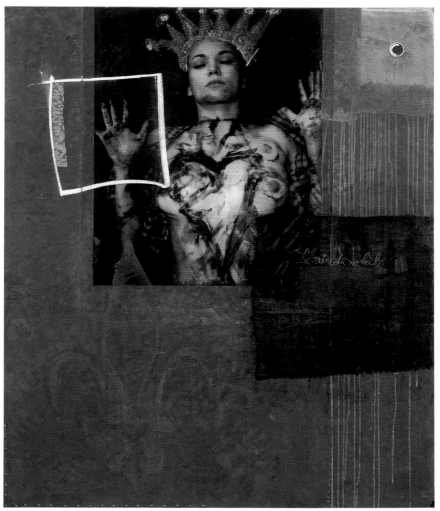

La Reine du Soleil, 1998

FOR SANDY DENNIS

1.

IN AN OMAHA STEAKHOUSE FULL OF INDIAN SUMMER
SUNDAY DINNER FEASTING FAMILIES YOU MODESTLY
CELEBRATED WHAT YOU KNEW WOULD BE THE CLOSEST
THING TO A GOODBYE GLIMPSE OF HOME BY EATING AND
DRINKING AS IF WILLING THE RED-ROBED WALLS TO FALL
ON OUR TABLE WITHOUT A THOUGHT FOR THE CANDLE
FLAME THAT WOULD SURELY GET SUCKED OUT AS THE
PARTICLEBOARD AND PLYWOOD LEFT THE DOOR FRAMES
AND WINDOWSILLS BEHIND AND RUSHED TO THE FLOOR
WITH A LAST GASP OF GENERATIONS OF PAINT AND
WALLPAPER GLUE SWIRLING INTO YOUR LUNGS.

2.

NO MOVIE CAN SHOW YOUR EYES AS THEY LOOKED AFTER
COMPLETING ONE LAST SCENE PLAYING OUR MOTHER,
WHEN YOU LIMPED OUTSIDE, WORN OUT AND
UNCOMPLAINING, TO SQUEEZE ONTO THE FLIMSY,
RUSTED SEAT OF A CHILD'S SWINGSET FOR A PHOTO
OPPORTUNITY. YOUR SHAKY HANDS GRIPPED THE CHAINS
AND I FELT YOUR BACK TENSE WITH THE STRAIN OF
HOLDING ON TO THE UNBEARABLY RIPE FRUIT OF A
HALF-STOMACH, BUT YOU ALLOWED YOUR SWOLLEN
FEET—AT LAST FREED OF THOSE HORRIBLE SANDALS—
TO TRAIL BACK AND FORTH IN THE COOL SEPTEMBER
GRASS OF THE UNMOWED BACKYARD.

3.

YOU'RE PACKED AND READY TO GO EARLY THE NEXT
MORNING, SITTING ON THE WELL-MADE BED IN A FRESH
DRESS AND HUMMING SLIGHTLY OUT OF BREATH WITH
THE RADIO, DONE HOURS AGO WITH FIGHTING OFF
DREAMS.

4.

YOU'VE PULLED APART THE HEAVY HOTEL DRAPES TO LET
IN THE SUN, AND EXCLAIM THAT THERE ISN'T A CLOUD IN
ALL THAT BLUE AS IF YOU'D NEVER SEEN SUCH A SKY.

5.

I CARRY YOUR SUITCASE DOWNSTAIRS AND WE EMBRACE
IN THE CIRCULAR DRIVEWAY. I WORRY THAT I'M HOLDING
YOU TOO TIGHT, AND START TO LET GO. REFUSING TO LET
ME TAKE YOU TO THE AIRPORT, YOU KISS ME ON THE
FOREHEAD AND GET IN A TAXI.

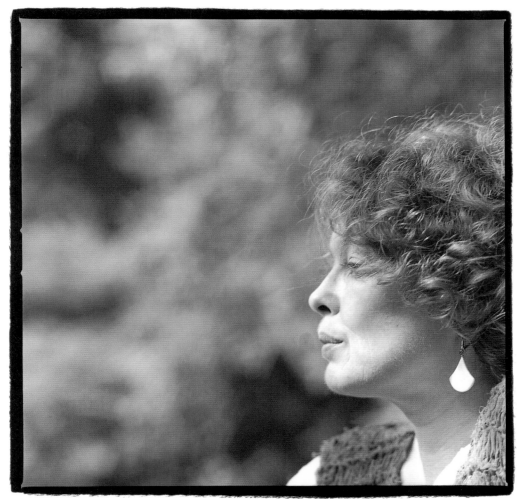

Sandy Dennis, 1985

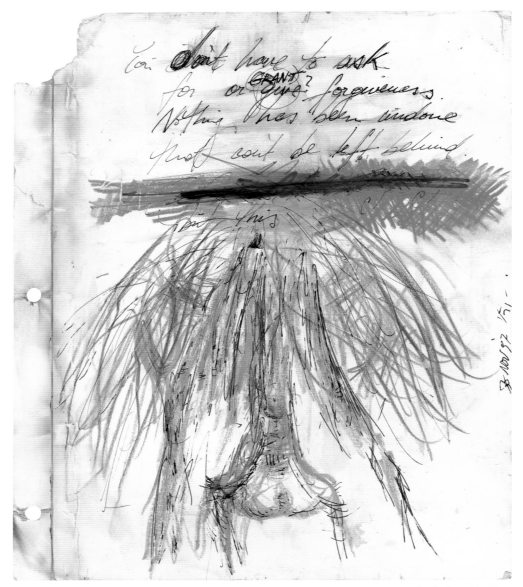

Confession #51, 1997

Memory, East-West, 1997

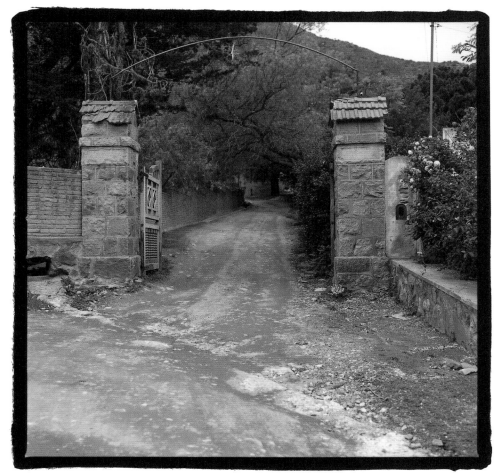

School, 1996

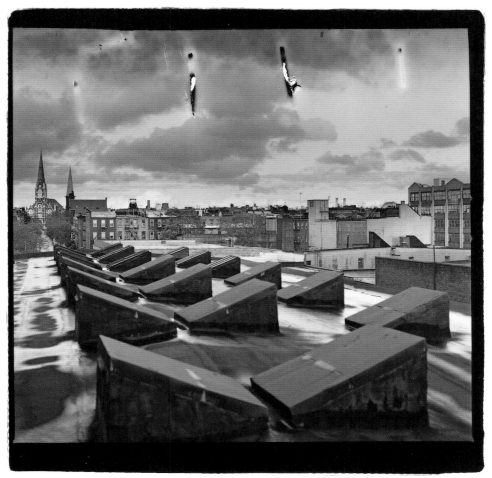

From Greenpoint Terminal, 1997

HOME

He's got a deep, abiding respect
verging on idol worship
for where things end up.
There are unopened letters
in his refrigerator, a fake
fingernail in the soapdish,
shoes everyplace.
These things, and many more
leavings, fragments, balancing
reminders of a breeze
from a slammed door—
configurations of sanctified loose ends—
have become the living net
above which he performs
the movements that make
the clock work.

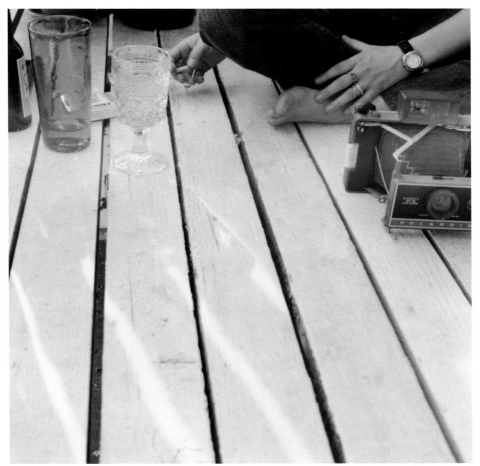

Blue #2, 1997

Green #2, 1998

THAT EAR
JOINING JAW
NO LOBE
TO SPEAK OF.
BLOOD RUNS
BUSY IN
BLUE BONE
UNDER YOUR
ALARMING
WHITENESS.

33

HACE DIAS QUE TE VEO DESDE ARRIBA.
LOS DEMÁS FINGEN VOLAR. ME GUSTAN
LOS AVIONES, PERO NO ME HACEN FALTA.
ESTUDIO MIS MANOS EN VEZ DE TUS OJOS.
¿CUANDO SABRÉ COMO TE LLAMÁS CUANDO
NADIE TE ESCUCHA? LA LLUVIA CANTA EN
LA CHAPA LOS SUEÑOS DE AYER, CADA GOTA
FRENADA POR EL TECHO DE LA COCINA
DONDE DUERMO CON EL GATO EN LA FALDA.

Home for a Holiday

Between cars rolling up to the intersection
a piece of the sun strobes weakly, pulls
his eyes through exhausted asphalt swells,
across the street and into a brick wall
that stands in for the horizon.

Nobody knows him here anymore.
He's walking the city east to west,
stopping only to absorb the surprise
feeling of belonging to himself
on a street corner as lights come on
in windows and late shoppers pass him by.

He leaves the road, hurries into the park
to relieve himself behind a eucalyptus,
and thinks of the first time he put his hand
up against the white tile wall over a urinal
in some airport when he was eight
after seeing his father do it.

Ontario

Her good moods were temporary as crackhouses, cloud shadows. She pulled flowers from the earth, turned out the lights, and went to the roof to read the love letter she had sent to herself. She finished other people's sentences for them, usually taking off on wild tangents that left the bushwhacked in stunned attendance on the strange rerouting of conversation. She walked leaning as far forward as gravity would allow, like a heron peeking into a hole in the ice. When she washed the windows, she tried in vain to see the other side of the lake, thirty-two miles away. Wore all her jewels all the time, sounding like a sack of broken chandeliers when she moved in her sleep. Sometimes she got sullen and withdrawn, and couldn't get anything done.

GOING

HE REMEMBERS DRIVING THROUGH THESE FARM VALLEYS AND GOVERNMENT LANDS YEARS AGO, IN A SUCCESSION OF WELL-MAINTAINED OLD CARS AND TRUCKS. BACK THEN HE WAS ALWAYS AT THE WHEEL AND USUALLY ALONE, CONSTANTLY CHECKING FOR SLIGHTEST CHANGE IN DETAILS OF FAMILIAR ROADSIDE SCENERY, TESTING HIS MEMORY FROM MILEPOST TO MILEPOST. HE HAD A NEED TO KNOW THE TERRAIN, TO REMIND HIMSELF OF THE SEQUENCE OF RIVERS, BRIDGES, MOUNTAIN PASSES, GOOD PLACES TO EAT AND SLEEP. HE'S NOT ALLOWED TO DRIVE ANYMORE, BUT DOESN'T MIND. HE'S MORE CONCERNED WITH THE TWO NEATLY TYPED LISTS THAT ARE TAPED TO THE BATHROOM DOOR OF HIS PRIVATE BUS THAN HE IS WITH WHAT'S OUT THE WINDOW. ONE LIST IS OF THE VARIOUS MEALS, PILLS, DROPS, SHOTS, AND EXERCISES HE MUST TAKE TO KEEP HIS BODY AND MIND FUNCTIONING WITH REDUCED FEAR OF SUDDEN COLLAPSE. THE OTHER ONE IS OF HOSPITALS, DOCTORS' HOME PHONE NUMBERS, SPECIAL DRUGSTORES—COMPLETE WITH ADDRESSES, EXACT DIRECTIONS, FREEWAY EXIT NUMBERS FOR EACH COMMUNITY. UNDERNEATH THAT IS NICELY HANDWRITTEN "YOU'RE AS YOUNG AS YOU FEEL." HE HASN'T BEEN ABLE TO PERSUADE ANY OF HIS NURSES TO CROSS IT OUT. LATELY, HE'S BEEN READING A FAIR AMOUNT, CONCENTRATING ON COMIC-BOOK COMPILATIONS. TODAY HE'S FAMILIARISING HIMSELF WITH RECENT VARIATIONS IN THE X-MEN SERIES. HE'S CONSIDERING TRYING HIS HAND AT SOME IDEAS HE'S DEVELOPED CONCERNING WOLVERINE AND HIS OUTFITS; MIGHT SEND SOME SKETCHES IN TO MARVEL. EVERY NOW AND THEN HE HAS A LITTLE CRISIS, AND WE CALL AHEAD TO PREPARE THE NEAREST EMERGENCY WARD FOR HIS IMMINENT ARRIVAL. WE ARE VERY ORGANISED, AND THERE ARE AT LEAST TWO OF US AWAKE AT ALL TIMES. EVERYTHING HAS WORKED OUT SMOOTHLY SO FAR.

PROGRESS

I HAVE RECORDINGS OF OUR VOICES
IN ROOMS NOW COLLAPSED, OF US RUNNING
THROUGH BLUE BUILDINGS THAT STOOD
FIFTY YEARS. SOUNDS FROM A SCHOOL
WHERE YOUR FOREHEAD WAS REOPENED
ON THE SHOE-SHAPED SLIDE. PICTURES
OF THE TEAL-GREEN TUX YOU WANTED
FOR KINDERGARTEN GRADUATION. OF YOU,
WET-COMBED HAIR AND RED-FACED HAPPY,
SITTING WITH YOUR MOTHER, EATING CAKE.

Bedtime Story for Henry

A big white bear sits on top of a white hill way up north—so far north that there are no trees, only snow. Rolling whiteness that seems to go on forever. He is as white as the snow, so he can't be seen. He sits there every day and watches from the hilltop, waiting for something to pass by. The sun is shining today and the sky is blue, so he can see far. First, seven reindeer cross in front of him, the biggest one breaking trail in the snow for the others to follow. After they disappear, a wolf trots by, sniffing and looking around as he goes. He's tracking the reindeer. A little later, an eagle flies high overhead, circles lazily three times in front of the sun, then floats away. Now the bear sees something he has never seen before. Stumbling along the reindeer trail is a large creature, walking on its hind legs. It is not graceful. It is not fast. It is noisy and it looks very tired. It is Candy Williams, a remarkably fat woman who doesn't know where she is going. She is wearing white cowboy boots, pink jeans, and a yellow silk shirt covered with feeding stains and throw-up. Over that, she wears a short, synthetic white fur coat. She used to have on an expensive pink cowboy hat, too, but she lost it somewhere. She is wet, she is cold, and she is still a little drunk. Her husband is back at the hotel in Las Vegas. He doesn't know where she went. She took the money he won at cards and flew to Anchorage. Then she chartered a plane to the farthest outpost she could get to. Then she paid an Eskimo a lot of money for his snowmobile and drove it straight out into the wide open whiteness until it ran out of gas. Then she ran out of booze. She has been drunk for a long time. She is trying to keep going. She is not where she wants to be yet.

The bear does not know all these things. He only knows that this is something he has never seen before.

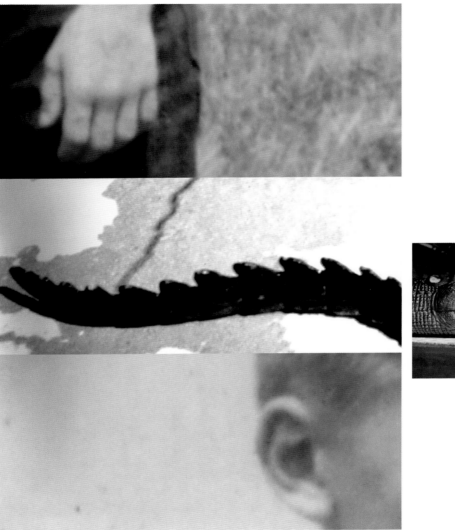

Teeth, 1998

Memory, North-South, 1998

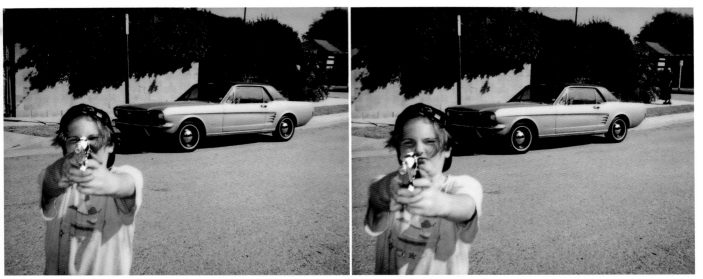

Double Tap, 1998

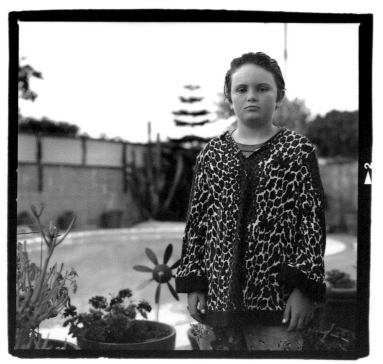

10 A.M., 1998

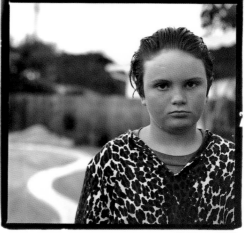

10:02 A.M., 1998

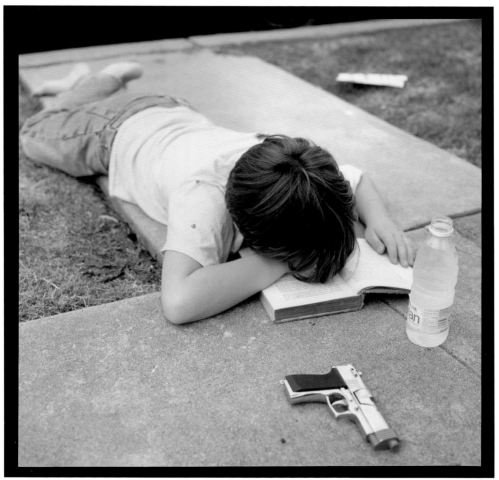

3 P.M., 1998

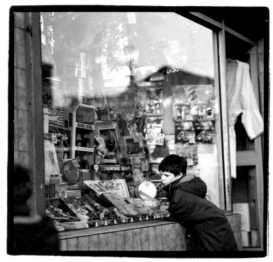

Belfast Christmas, 1992

CHACO

ME CAGO EN LA SELVA,
COMO LOS MONOS
CON SUS DIENTES
PERFECTOS Y AMARILLOS,
SIN TENERLE MIEDO
A NINGUN TIGRE.

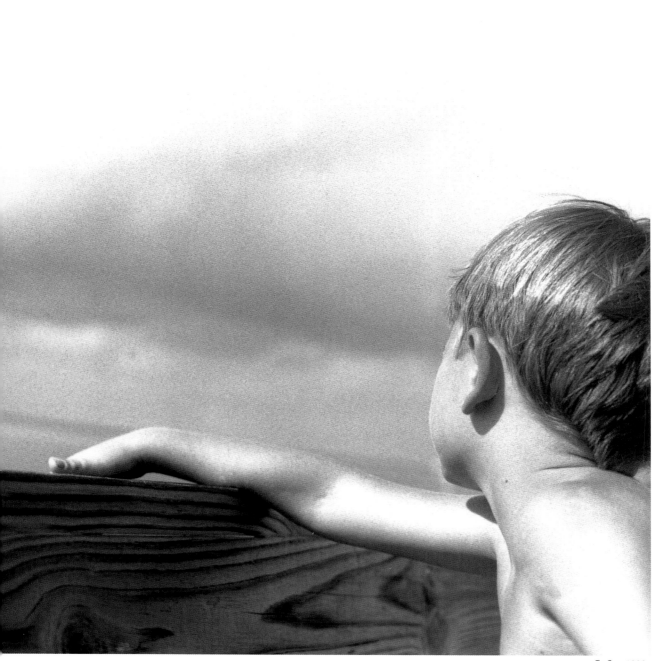

To Sea, 1993

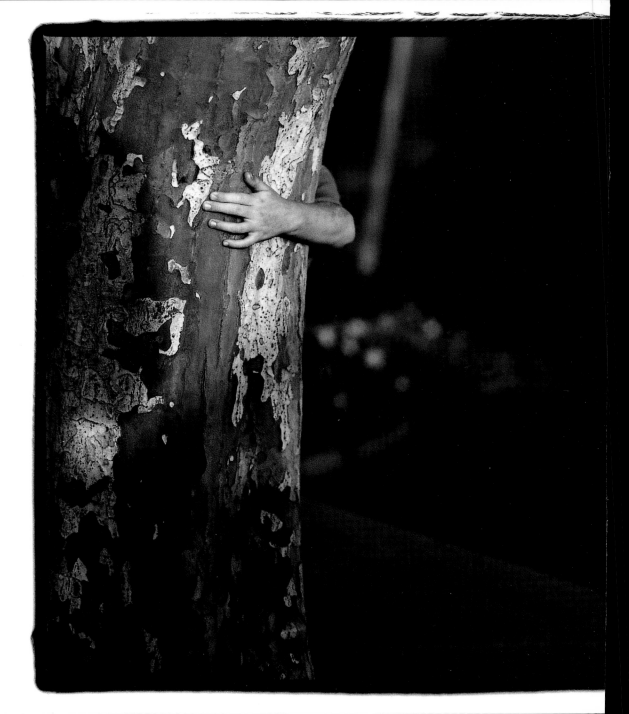

HILLSIDE

WE UNDERESTIMATE DAMAGE
DONE TO THE SKY
WHEN WE ALLOW WORDS
TO SLIP AWAY
INTO THE CLOUDS.

I REMEMBER MAKING PROMISES
TO YOU OUTSIDE. WE
WERE WATCHING FLOWERS
THAT HADN'T OPENED.
A BEE DARTED, CAREFUL
NOT TO STICK TO
YOUR HALF-SHUT MOUTH.

6:10 P.M., 1995

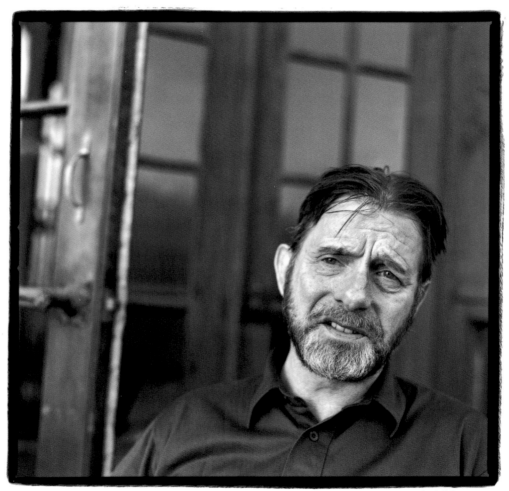

Jack Kehoe, 1995

ATTENTION.

Anna, 1997

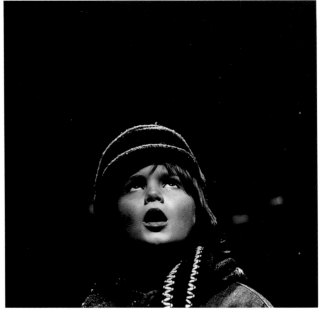

Eiffel Tower, 1995

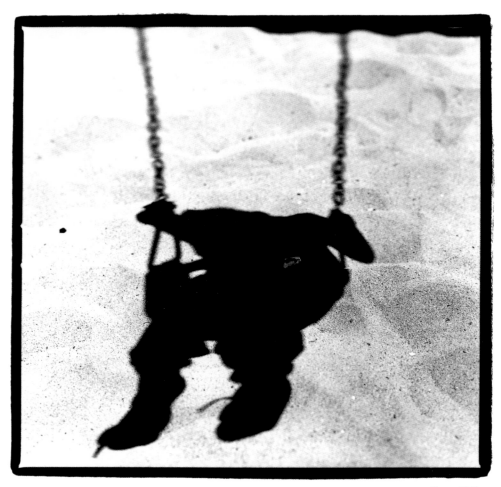

Henry, 1990

SMART READER:

BEFORE THE CELEBRITY CAME THE POET, THE PAINTER, THE PICTURE-TAKER. VIGGO MORTENSEN HAS ALWAYS BEEN THE REAL THING, AS EVIDENCED BY THIS PROUD PUBLICATION, BEAUTIFULLY DESIGNED BY JULIE WILLIAMS AND ELLEN WAKAYAMA, AND EDITED BY PILAR PEREZ.

— TOM PATCHETT

A SAMPLING OF OTHER SAP MONOGRAPHS:

MANUEL OCAMPO: HERIDAS DE LA LENGUA

THIS BEAUTIFULLY ILLUSTRATED BOOK DOCUMENTS ONE OF THE MOST IMPORTANT YOUNG ARTISTS TO HAVE EMERGED FROM LOS ANGELES IN THE LAST DECADE, WHOSE WORK UPDATES THE TRADITION OF POLITICAL ALLEGORISTS LIKE GERICAULT, GOYA, DAUMIER, AND GOLUB.

SOFTCOVER, $10^{1}/_{2}$ X 11 IN., 80 PP
64 COLOR, 12 B&W ILLUSTRATIONS
ISBN 1-889195-10-3 $30.00

RUSSELL FORESTER: UNAUTHORIZED AUTOBIOGRAPHY

A THIRTY-YEAR RETROSPECTIVE OF FORESTER'S PAINTINGS, DRAWINGS, SCULPTURES, AND INSTALLATIONS WHICH LOOKS AT HIS ART IN THE CONTEXT OF HIS RELENTLESS EXPERIMENTATION AND HIS PARALLEL CAREER AS A RENOWNED AND AWARD-WINNING ARCHITECT.

SOFTCOVER, $7^{1}/_{2}$ X $7^{1}/_{2}$ IN., 90 PP
40 COLOR, 13 B&W ILLUSTRATIONS
ISBN 1-889195-08-1 $20.00

MAN RAY: PARIS>>L.A.

THE FIRST-EVER IN-DEPTH LOOK AT THE LIFE AND ART OF MAN RAY DURING THE DECADE HE LIVED IN SOUTHERN CALIFORNIA (1941–1950), THIS HANDSOME ILLUSTRATED BOOK DOCUMENTS THE LOCAL COLOR AND THE COLORFUL PERSONALITIES THAT DOMINATED THE SCENE, AS WELL AS MAJOR PAINTINGS, LETTERS, AND DOCUMENTS BY MAN RAY COMMENTING ON THE MOVIES AND LIFE IN CALIFORNIA.

SOFTCOVER, 9 X 12 IN., 128 PP
140 ILLUSTRATIONS
ISBN 0-9646426-8-9 $30.00

BEATTIE & DAVIDSON

FOR PAINTERS DREW BEATTIE AND DANIEL DAVIDSON, "TWO HEADS ARE BETTER THAN ONE, FOUR HANDS BETTER THAN TWO." SINCE 1989, THE NEW YORK–BASED DUO HAS PURSUED AN UNUSUAL CREATIVE PARTNERSHIP, WORKING TOGETHER AND IN ALTERNATION ON THEIR PAINTINGS AND COLLAGES. THIS BOOK COMPILES BEATTIE AND DAVIDSON'S LATEST WORK AND EXAMINES THEIR CLOSE COLLABORATIVE RELATIONSHIP. ESSAYS BY LARRY RINDER AND DAVID HUMPHREY.

SOFTCOVER, $11^{1}/_{2}$ X $9^{1}/_{2}$ INCHES, 72 PP
50 COLOR, 5 B&W
ILLUSTRATIONS
ISBN 1-889195-21-9 $20.00

SMART ART PRESS • 2525 MICHIGAN AVENUE, C1 SANTA MONICA, CA 90404
TEL: 310.264.4678 • FAX: 310.264.4682 • WEB: WWW.SMARTARTPRESS.COM